WONDROUS NATURE MANDALAS

A COLORING BOOK WITH A HIDDEN PICTURE TWIST

Jo Taylor

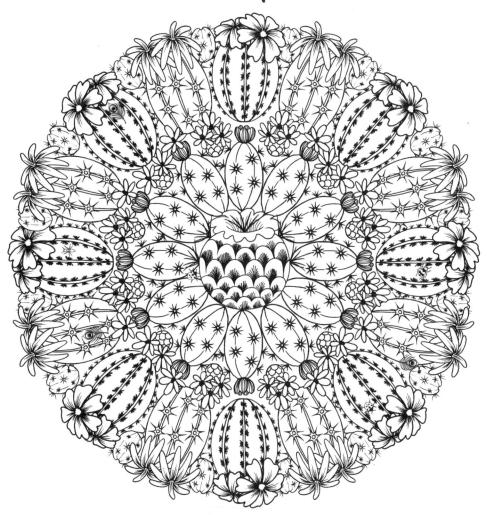

DOVER PUBLICATIONS, INC.
MINEOLA, NEW YORK

There are **167** hidden objects in these coloring pages!

Have fun finding them...

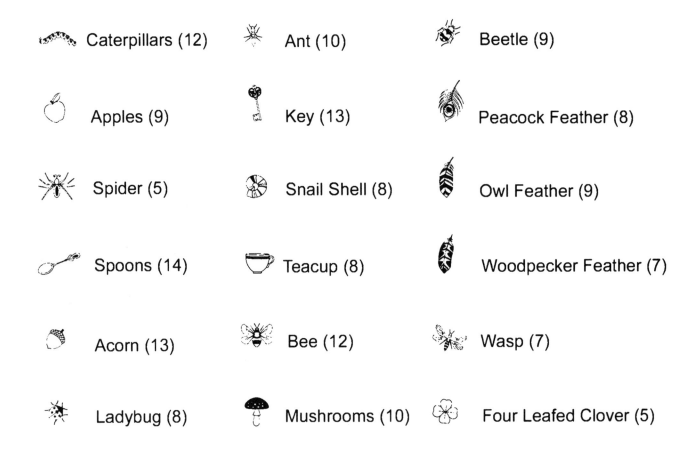

Caterpillars (12) Ant (10) Beetle (9)

Apples (9) Key (13) Peacock Feather (8)

Spider (5) Snail Shell (8) Owl Feather (9)

Spoons (14) Teacup (8) Woodpecker Feather (7)

Acorn (13) Bee (12) Wasp (7)

Ladybug (8) Mushrooms (10) Four Leafed Clover (5)

Bibliographical Note
Wondrous Nature Mandalas: A Coloring Book with a Hidden Picture Twist is a new work,
first published by Dover Publications, Inc., in 2016.

International Standard Book Number
ISBN-13: 978-0-486-80748-5
ISBN-10: 0-486-80748-7

Manufactured in the United States by LSC Communications
80748702 2018
www.doverpublications.com

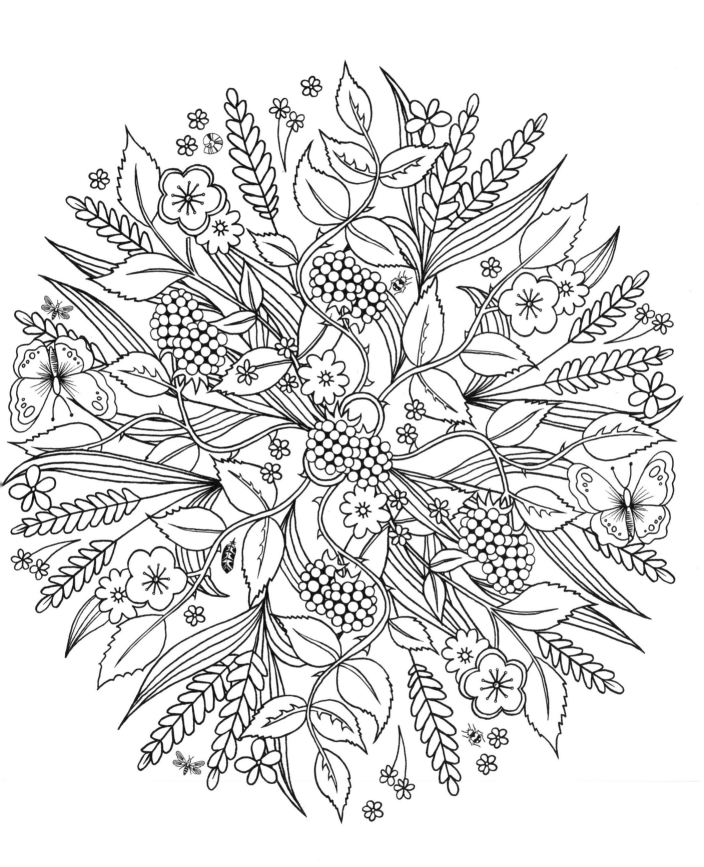

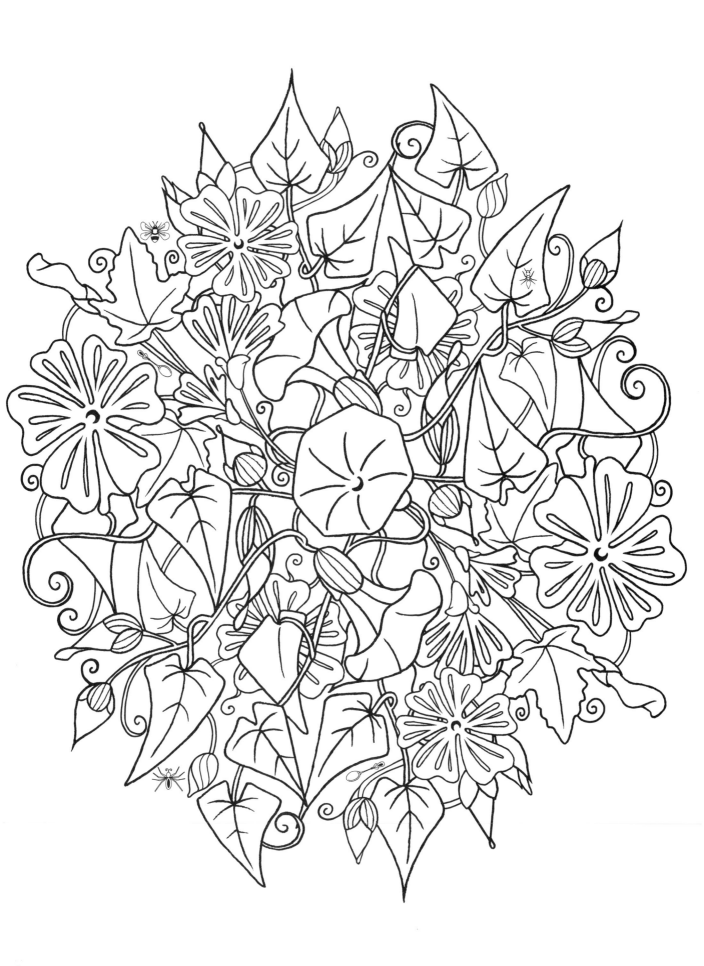

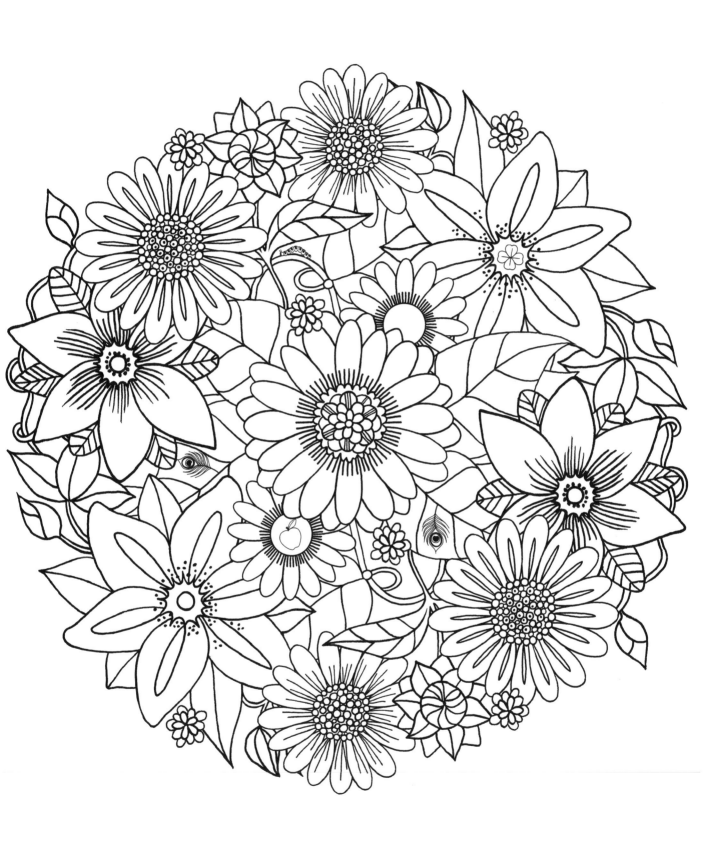

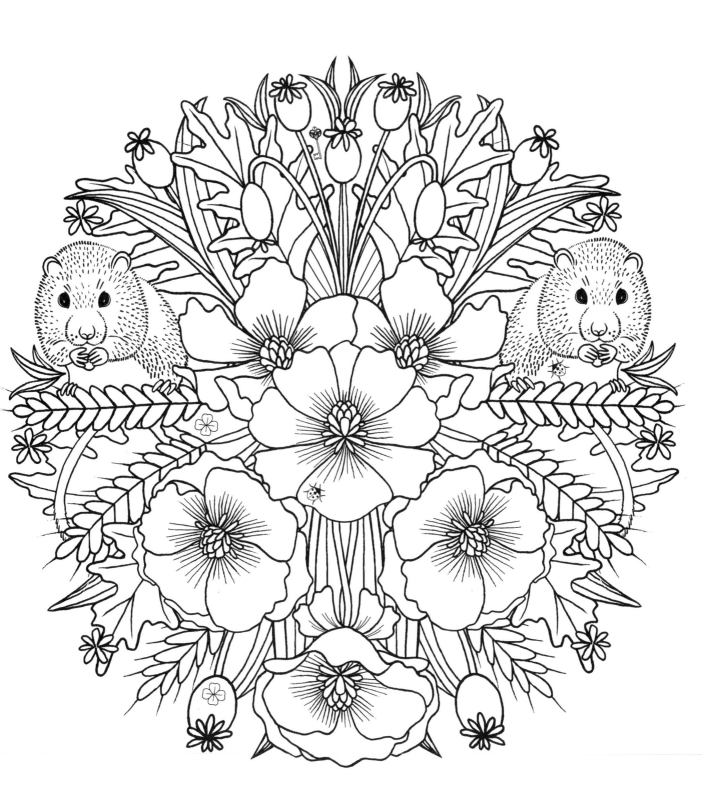

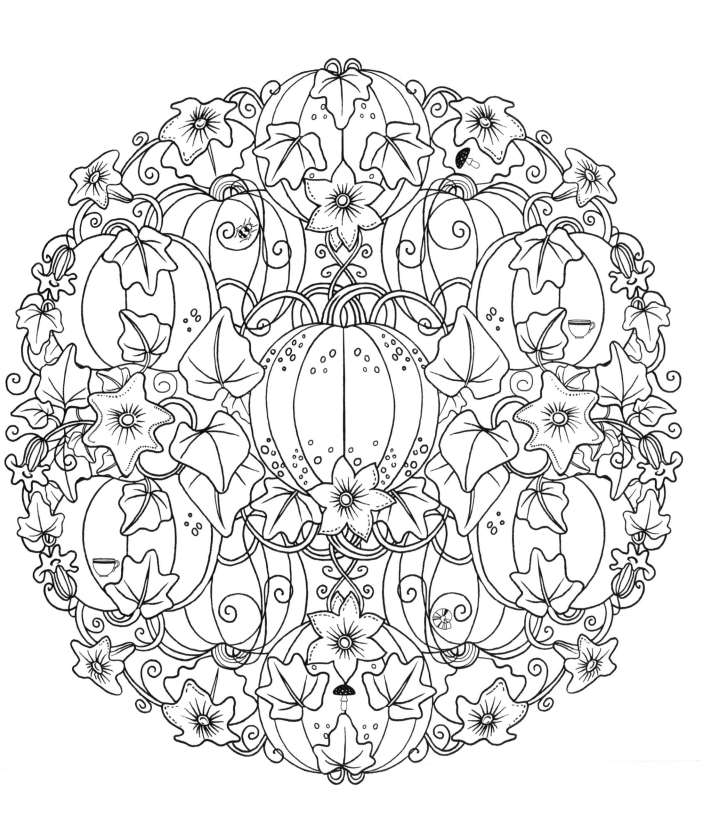

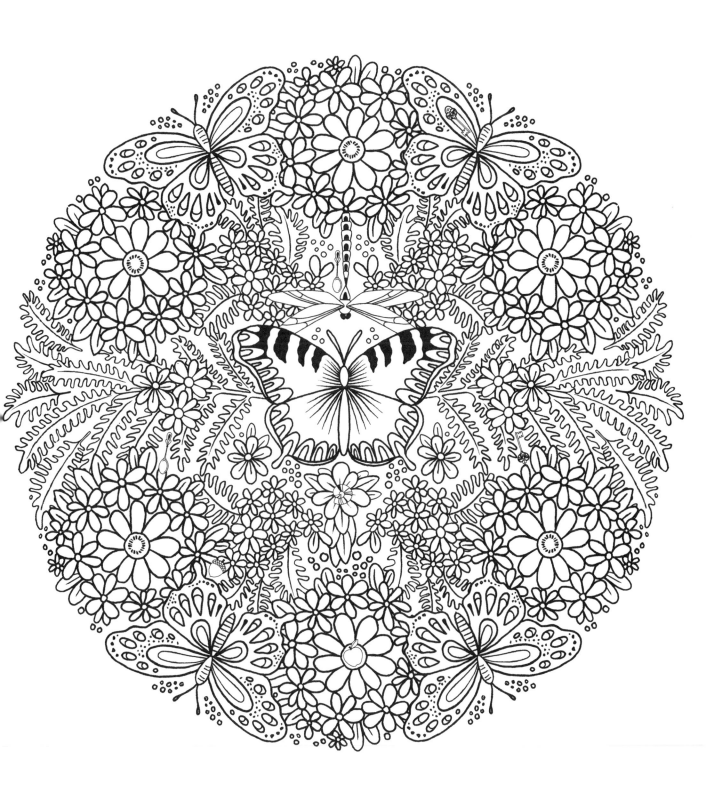

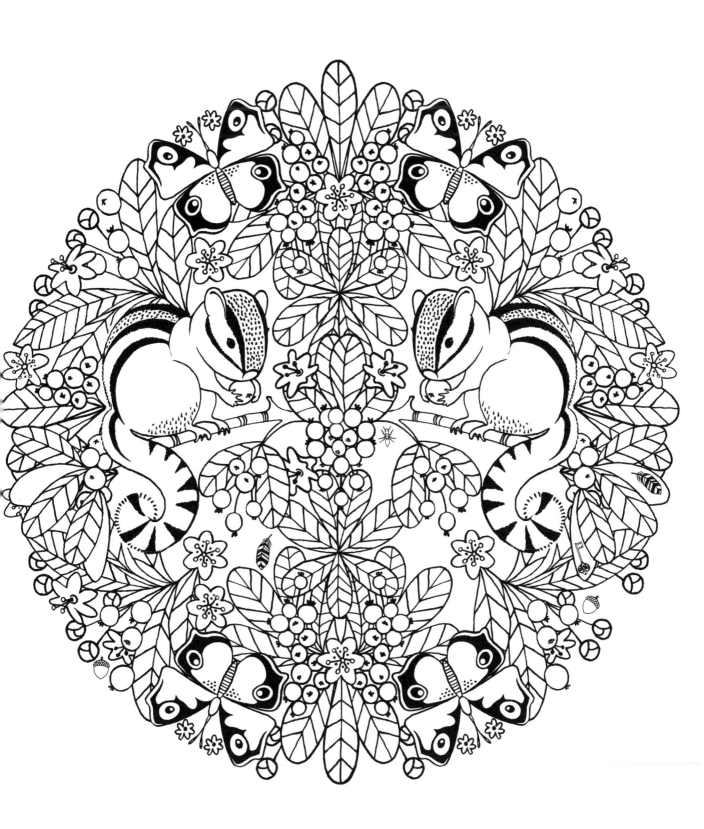

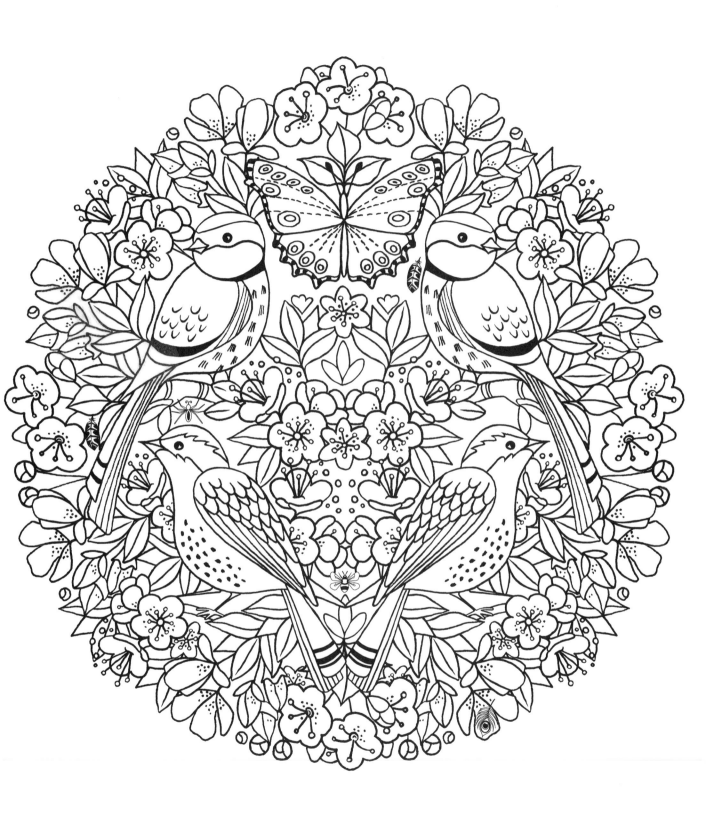

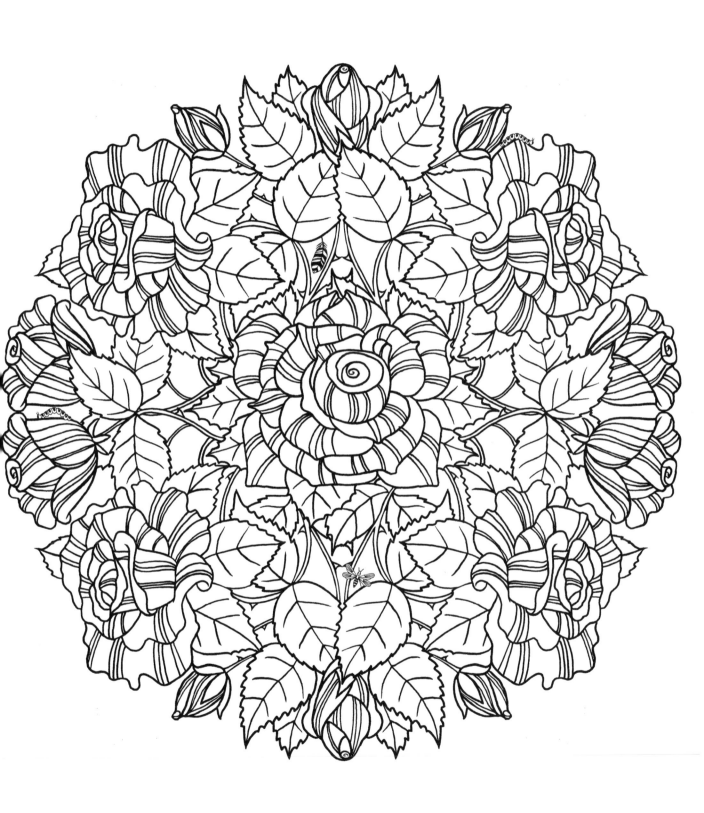

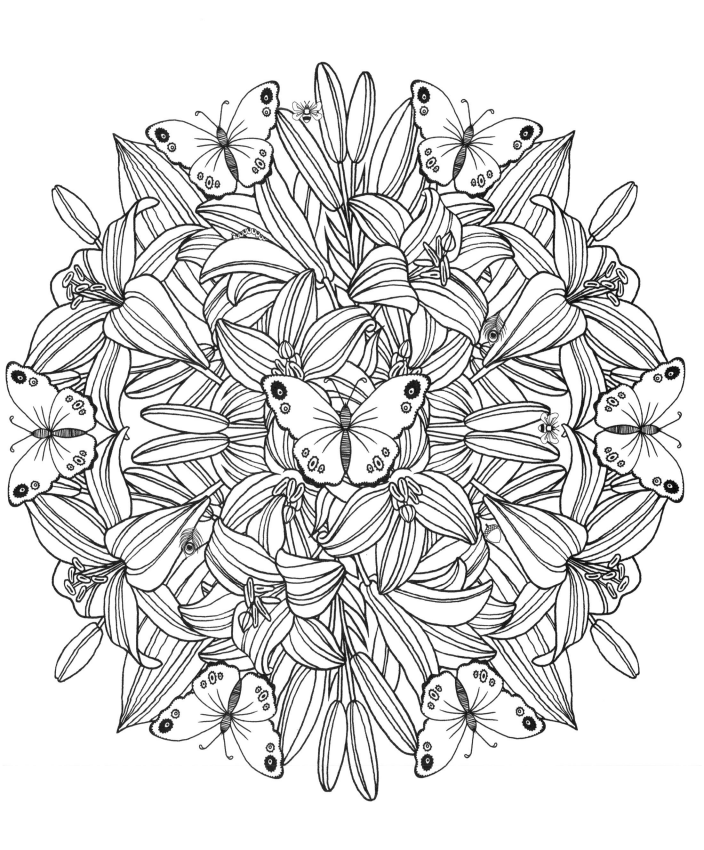

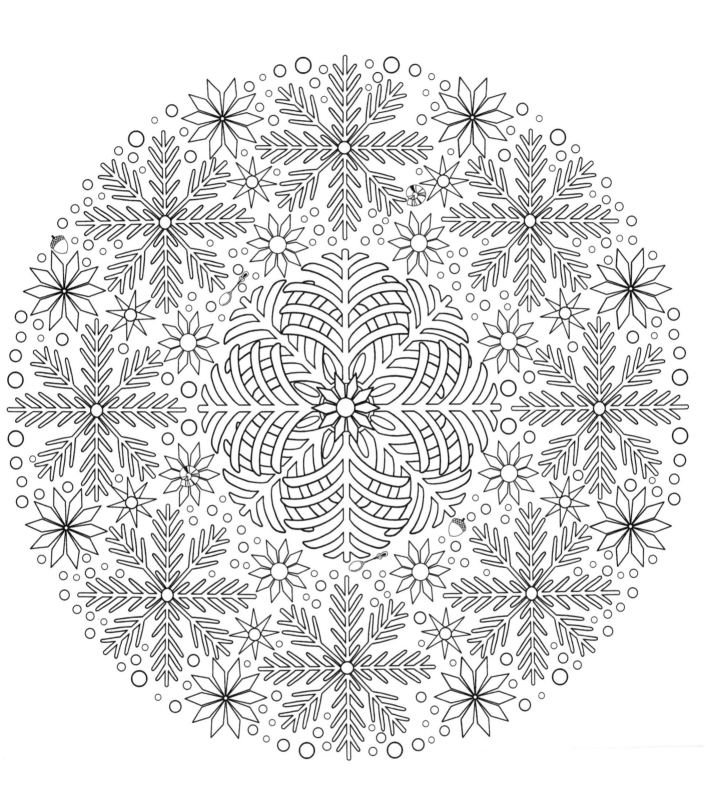

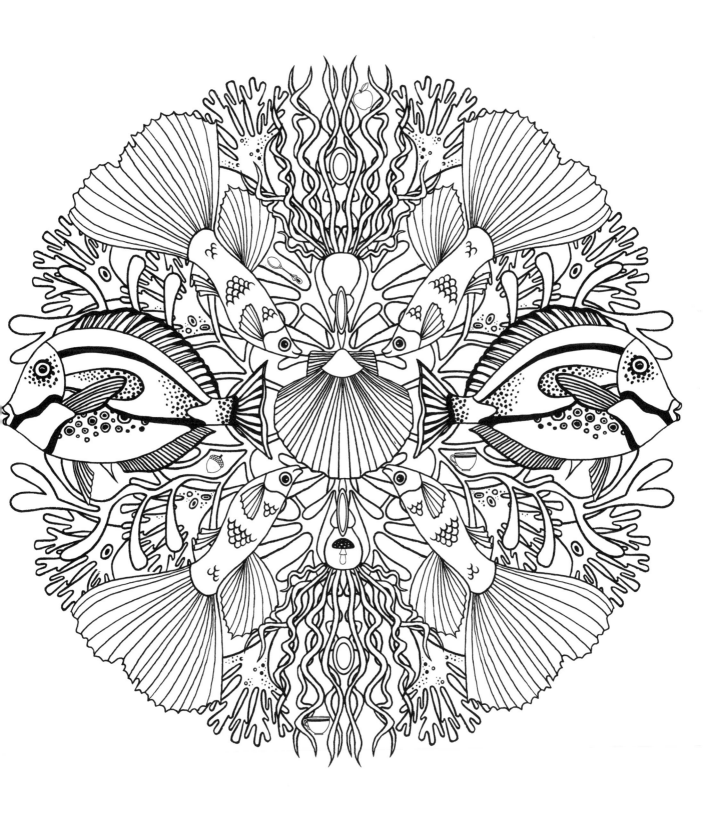

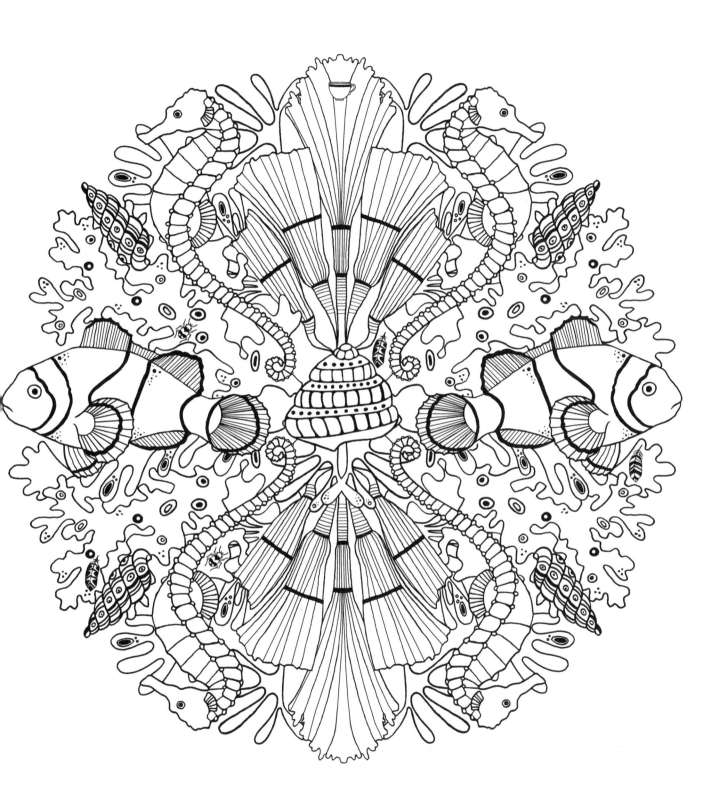

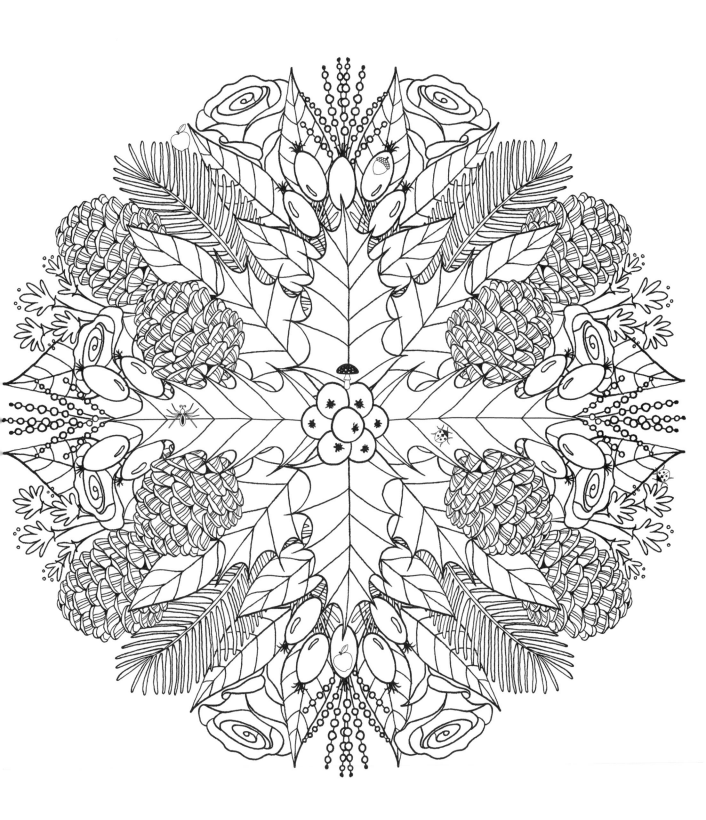

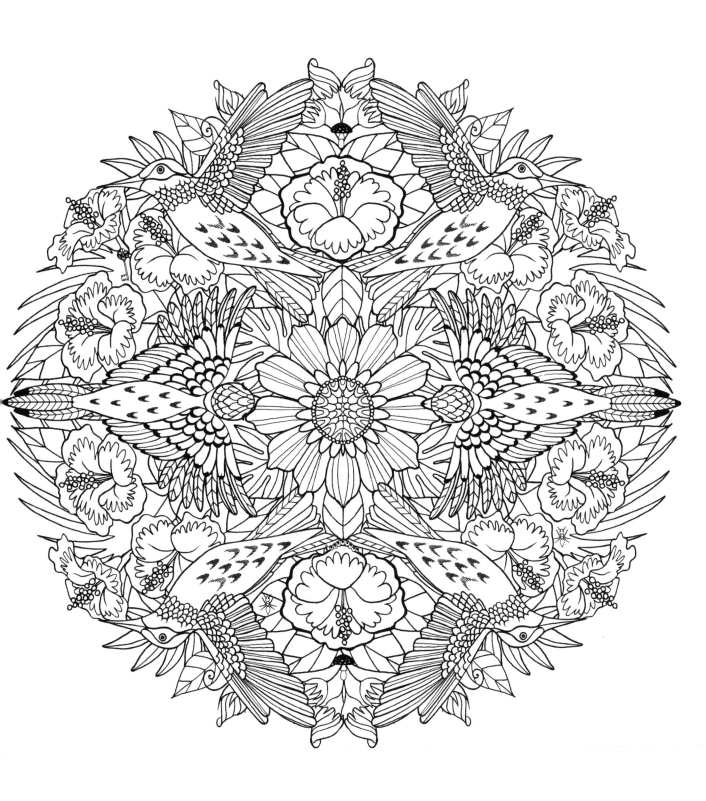

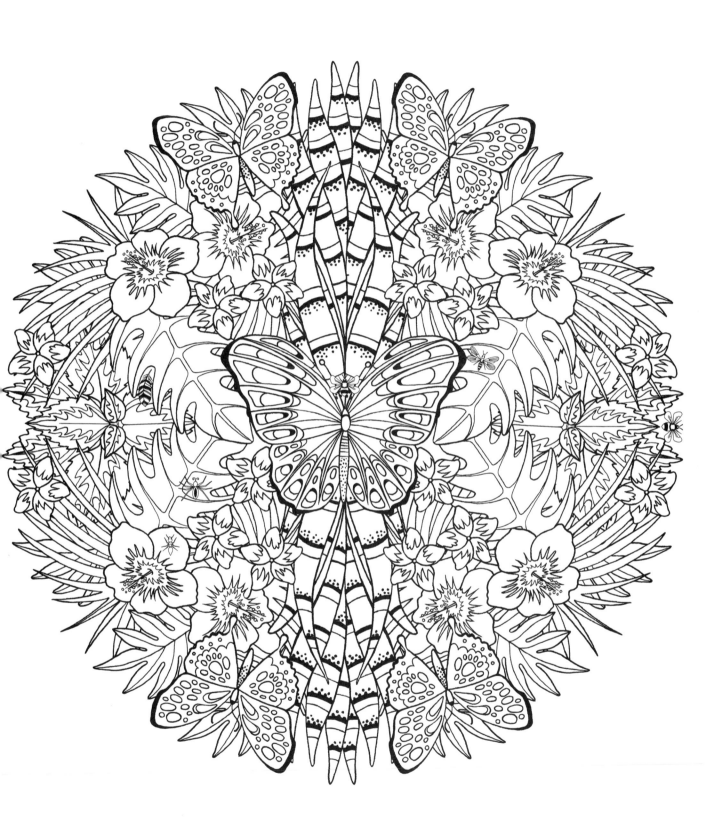

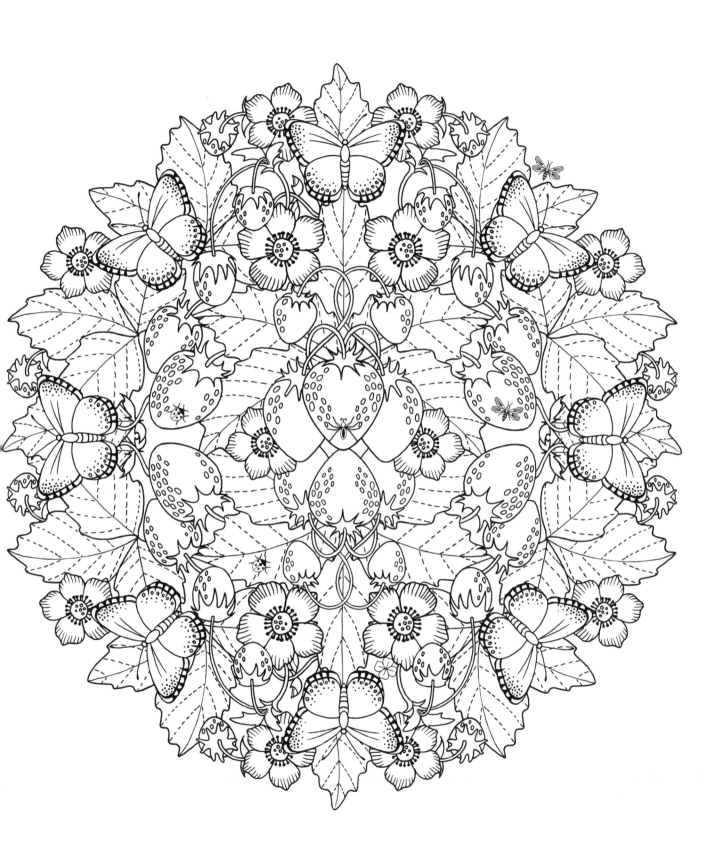

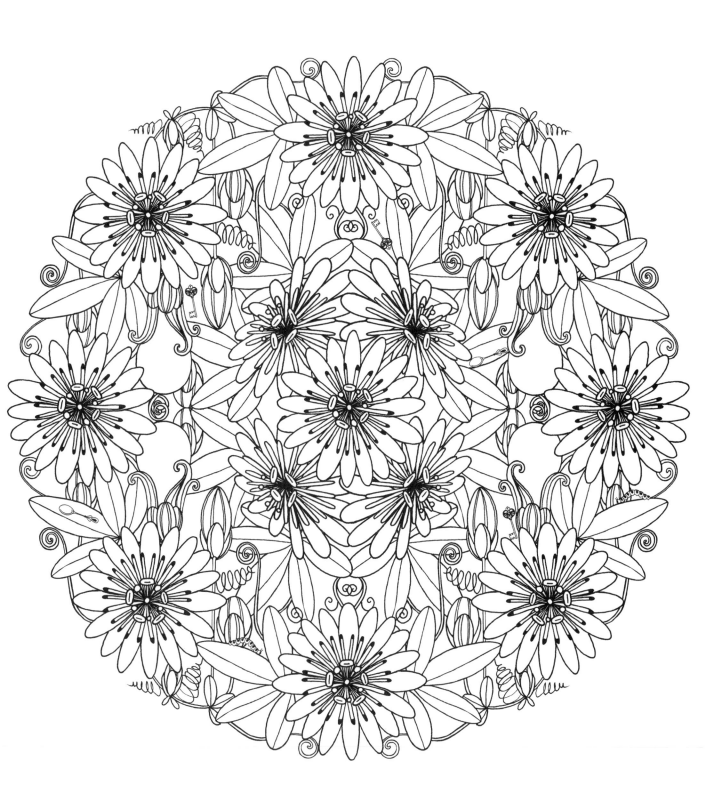

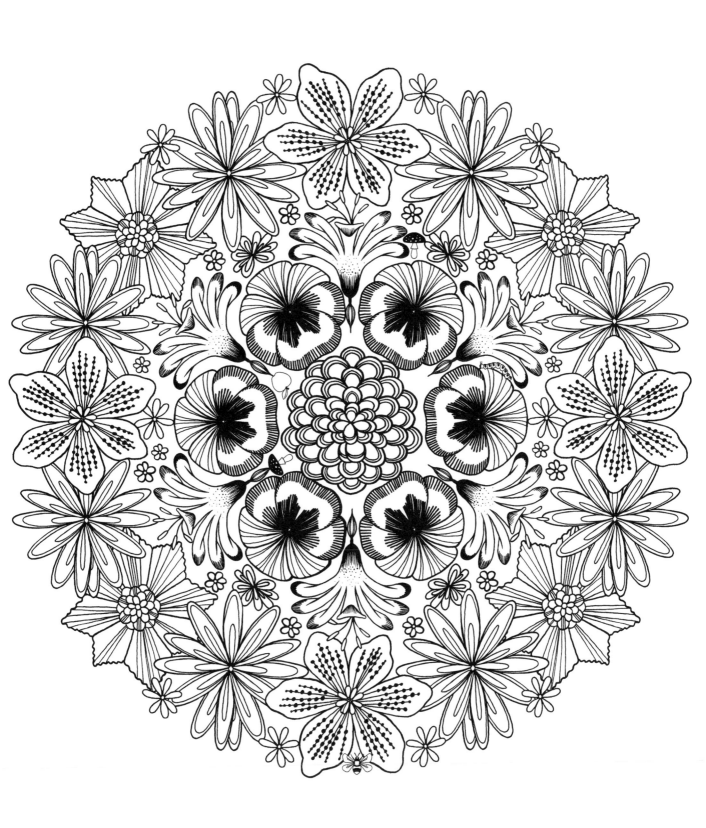

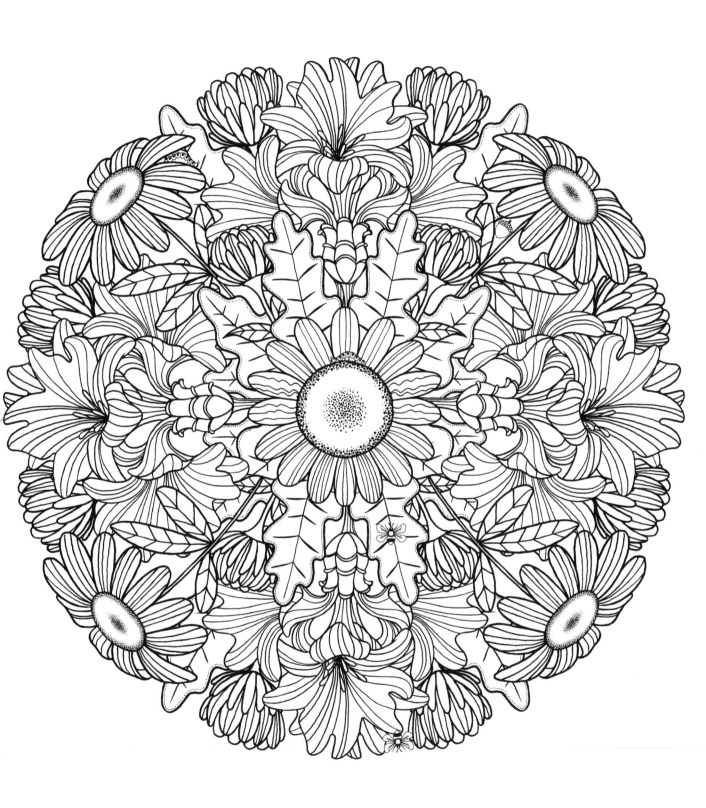

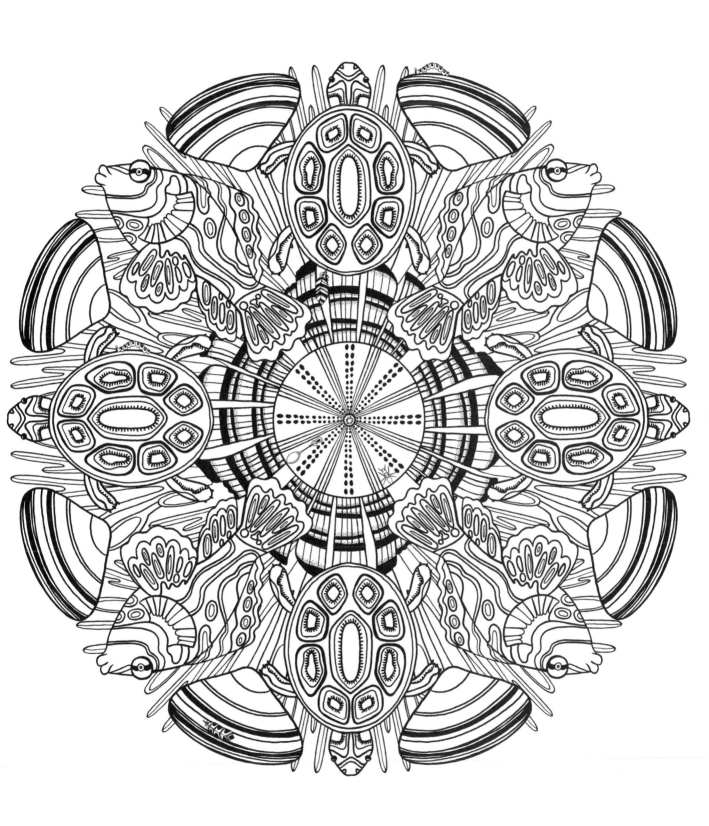

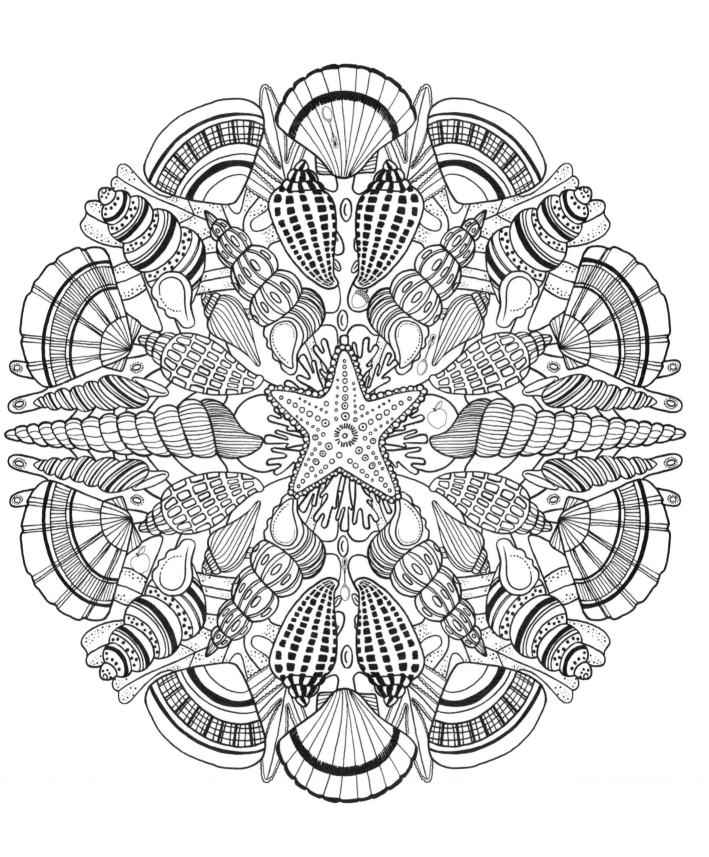

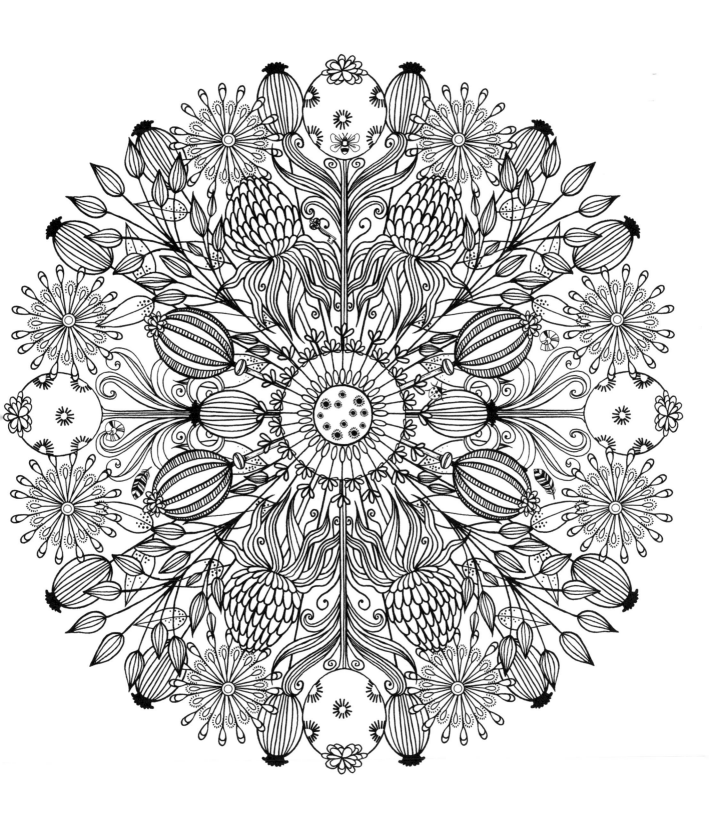

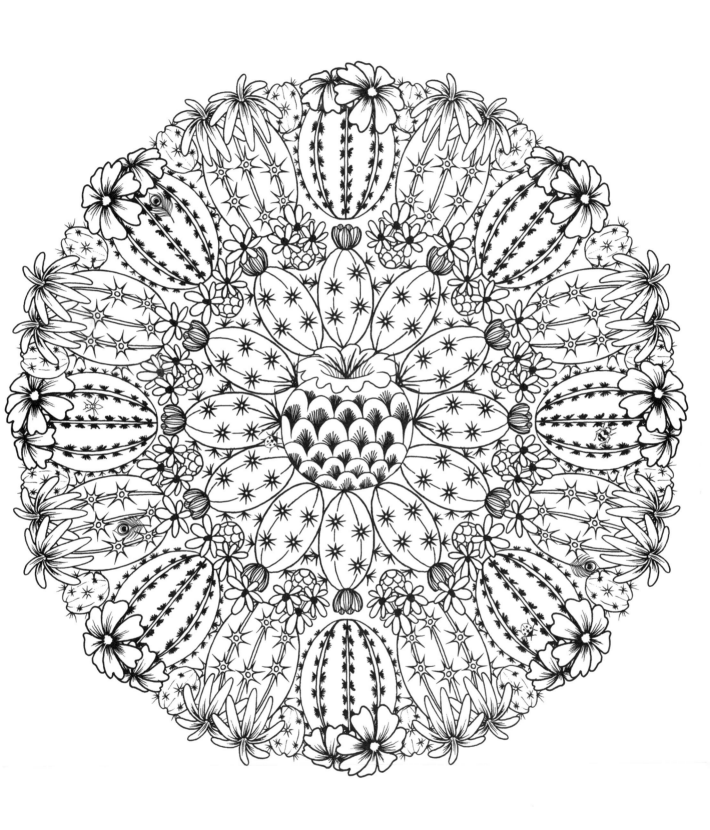

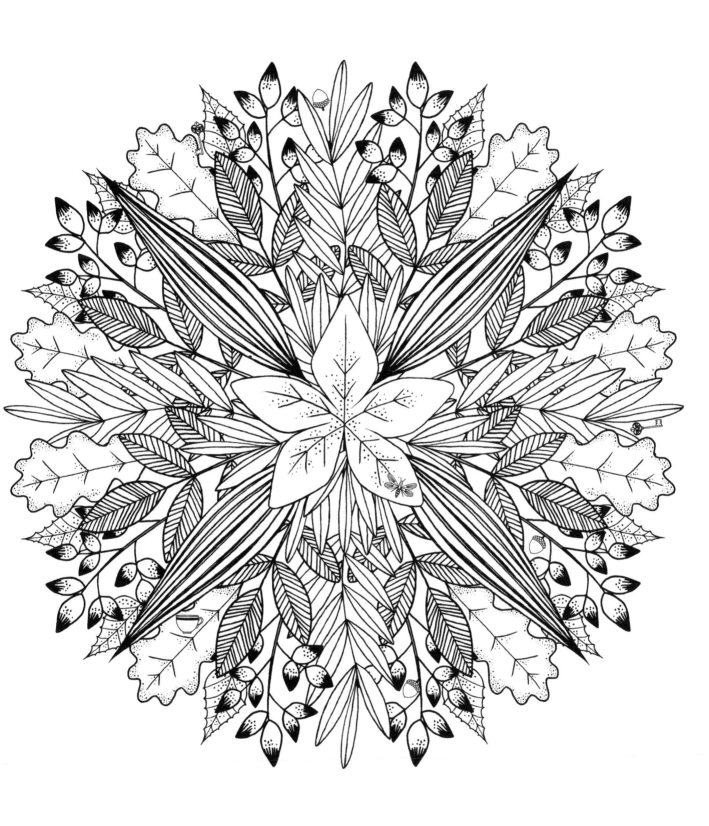

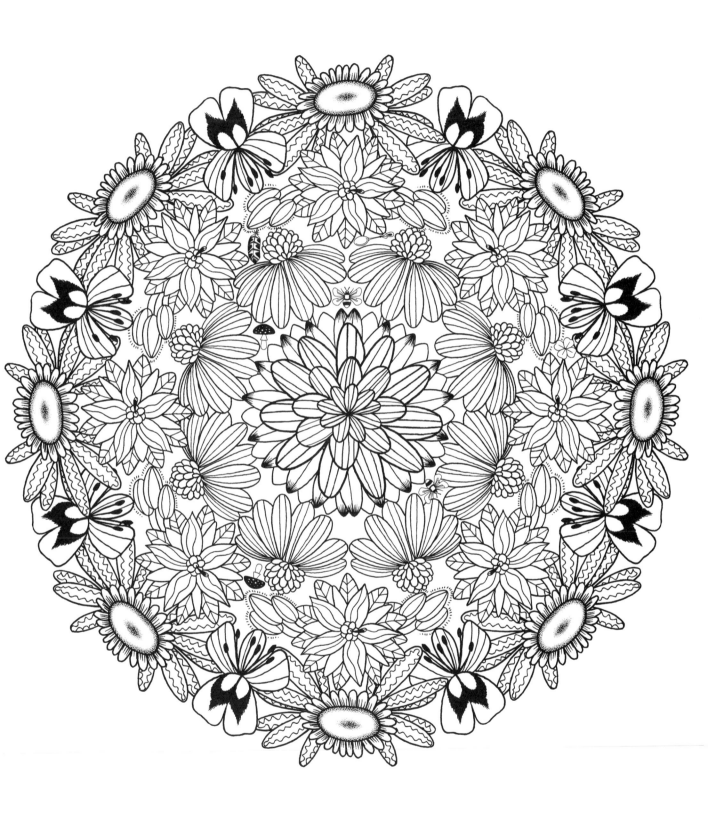

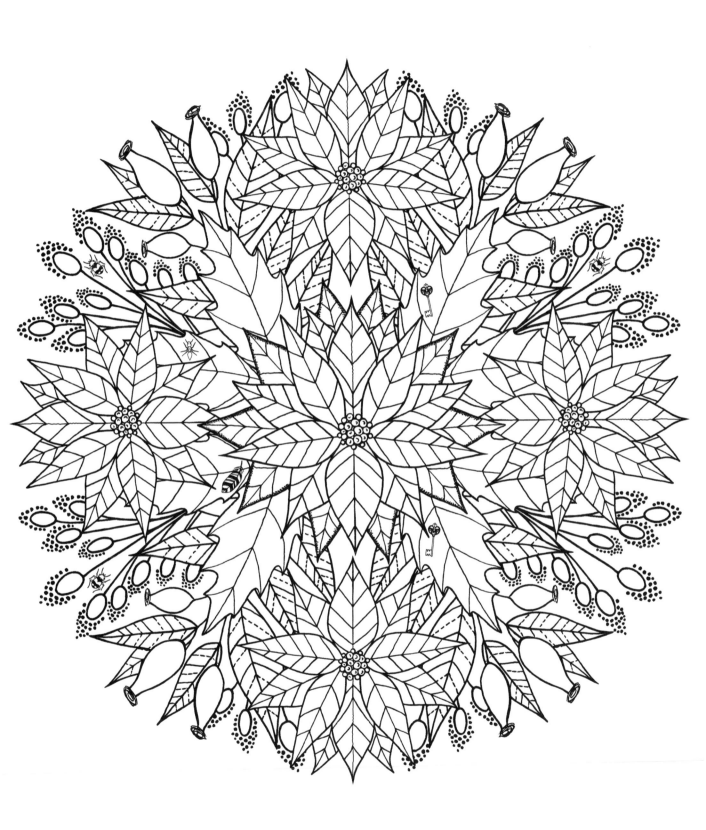

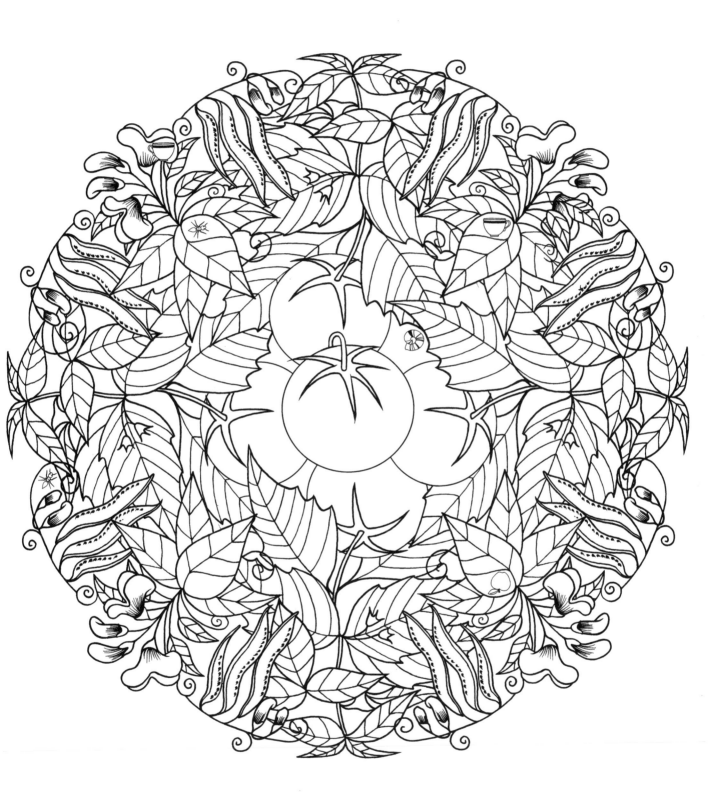

SOLUTIONS

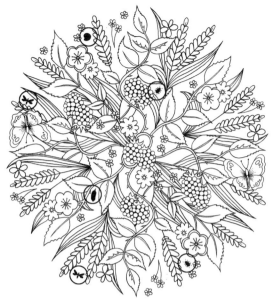

1. Woodpecker feather, wasp (2), beetle (2), snail shell

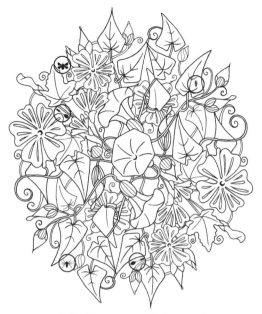

2. Spider, spoon (2), bee, ant

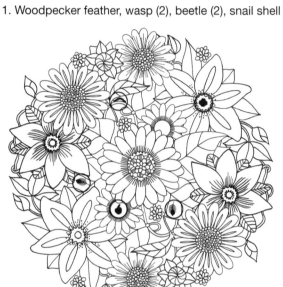

3. Caterpillar, apple, peacock feather (2), four-leaf clover

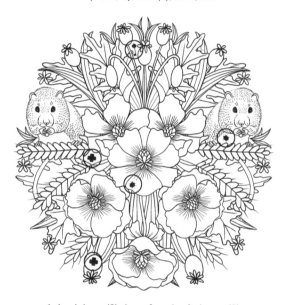

4. Ladybug (2), key, four-leaf clover (2)

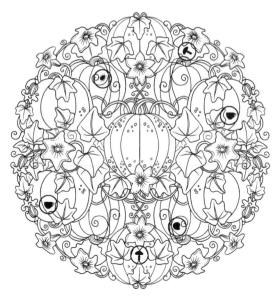

5. Mushroom (2), snail shell, teacup (2), beetle

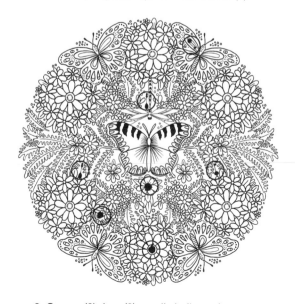

6. Spoon (2), key (2), snail shell, apple, acorn

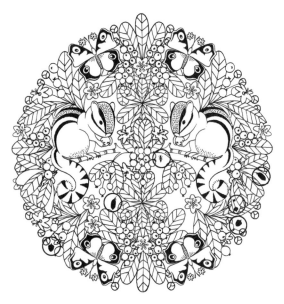

7. Owl feather (2) acorn (2), ant, key

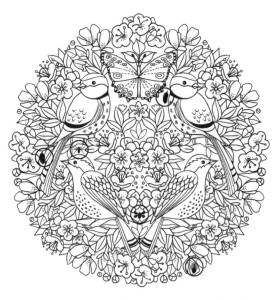

8. Woodpecker feather (2), spider, peacock feather, bee

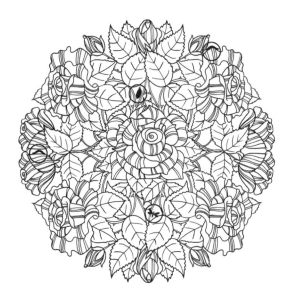

9. Caterpillar (2), wasp, owl feather

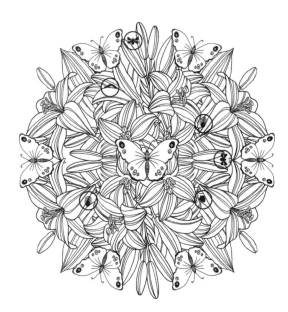

10. Caterpillar, peacock feather (2), bee (2), acorn

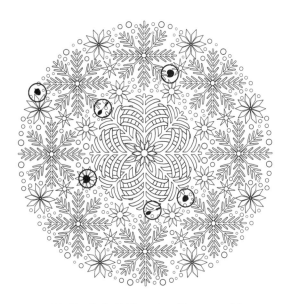

11. Snail shell (2), acorn (2), spoon (2)

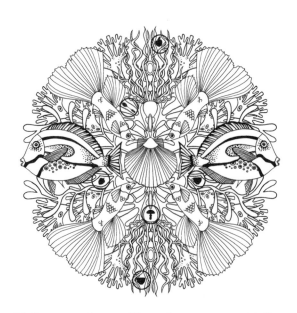

12. Teaspoon, teacup (2), mushroom, acorn, apple

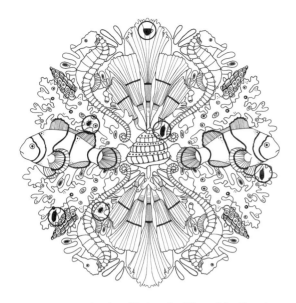

13. Woodpecker feather (2), beetle (2), owl feather, teacup

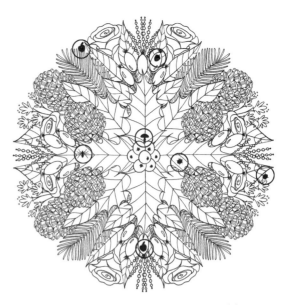

14. Mushroom, ladybug (2), spider, apple (2), acorn

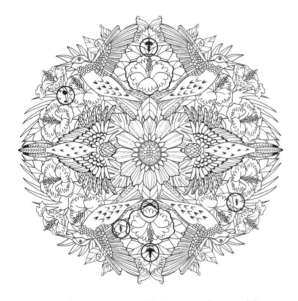

15. Caterpillar, ant (2), key, mushroom (2)

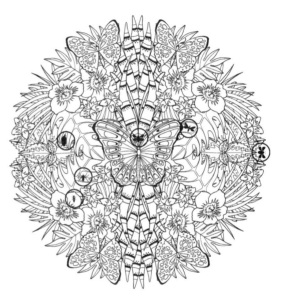

16. Bee (2), owl feather, wasp, ant, spider

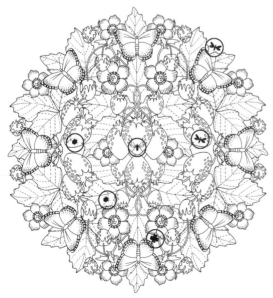

17. Wasp (2), four-leaf clover, ladybug (2), spider

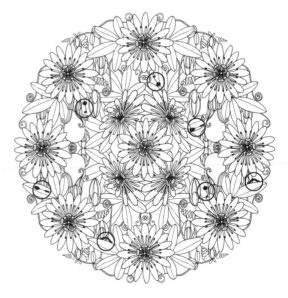

18. Spoon (2), key (3), caterpillar (2)

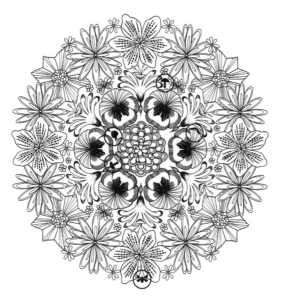

19. Caterpillar, apple, mushroom (2), bee

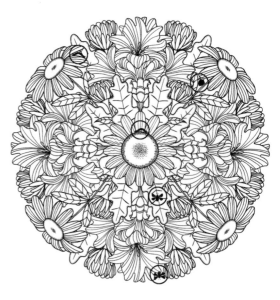

20. Bee (2), caterpillar (2), acorn

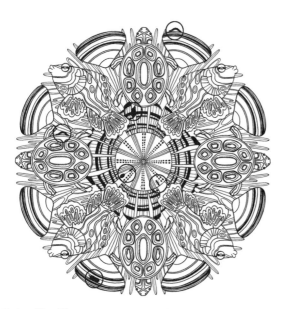

21. Caterpillar (2), spoon, ant, woodpecker feather, owl feather

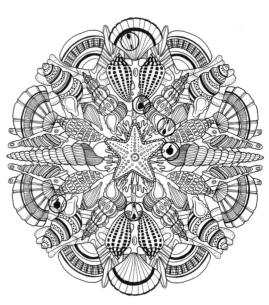

22. Acorn, apple (2), spoon (3)

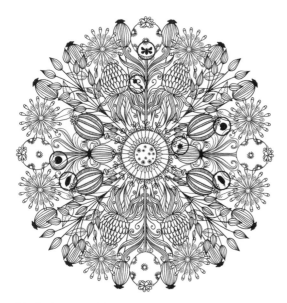

23. Owl feather (2), bee, snail shell (2), key, ladybug

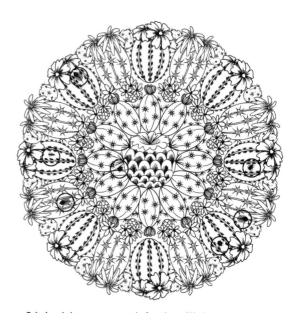

24. Ladybug, peacock feather (3), beetle, ant

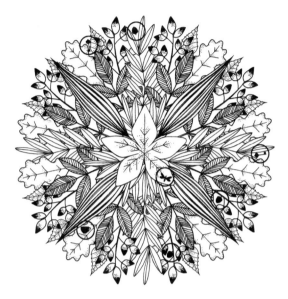

25. Wasp, key (2), teacup, acorn (3)

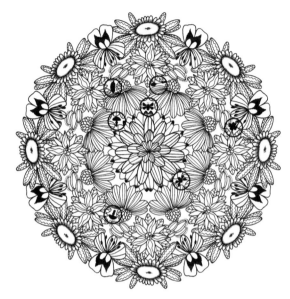

26. Mushroom (2), bee (2), woodpecker feather, spoon, four-leaf clover

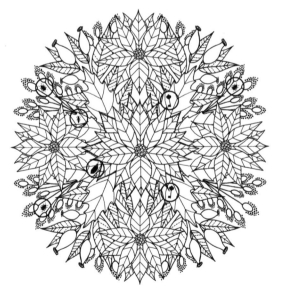

27. Ant, beetle (3), owl feather, key (2)

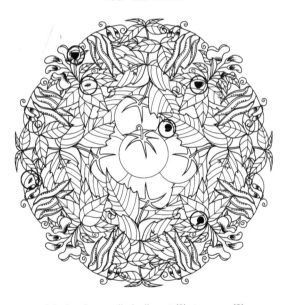

28. Apple, snail shell, ant (2), teacup (2)